the lettering book

noelene morris

SCHOLASTIC INC.
New York Toronto London Auckland Sydney

I dedicate this book to my husband Zora

ISBN 0-590-42277-4

12 11 10 9 8 7 6 5 4 0 1 2 3/9

Printed in the U.S.A. 08
First Scholastic Printing, October 1987

Contents

Parts of a Pageinside front cover

About this Book . 4

Planning a Poster . 5

Some Tips for Projects . 6

Text . 7

Designing a Page . 8

Headings . 9

Pictures and Captions .11

Drawings .13

Ways to Vary a Printing Style14

A Spacing Guide .15

Markers .16

Rules .17

Borders .18

Numerals .20

Sans Serif Lettering Styles .22

Serif Lettering Styles .46

Script and Decorative Styles .58

Glossary .inside back cover

About this Book

The Lettering Book is your 'ideas' book. It has hundreds of different styles of hand-drawn lettering from which you can choose. Practice a few of the easier lettering styles at first until you develop your confidence. You will soon find yourself experimenting, and in a short time you will have invented many styles of your own. Within this book there are also the alphabets of many popular typefaces that you may have seen in magazines, books and other printed material. These have been set out on special grids to help you copy them. When you wish to copy these letters, unfold one of the cover grids, place it under your paper and match the shape of each letter as you draw.

The first part of the book contains useful tips on the many ways you can present projects and posters, arrange headings and pictures, and design your work so that it looks attractive.

In these pages there are some technical terms that you may need to know for lettering, design or art work. If you come across one you do not understand, look it up in the glossary at the back of the book.

I hope *The Lettering Book* fills you with many ideas for exciting ways to use lettering and to design creatively.

Noelene Morris

Planning a Poster

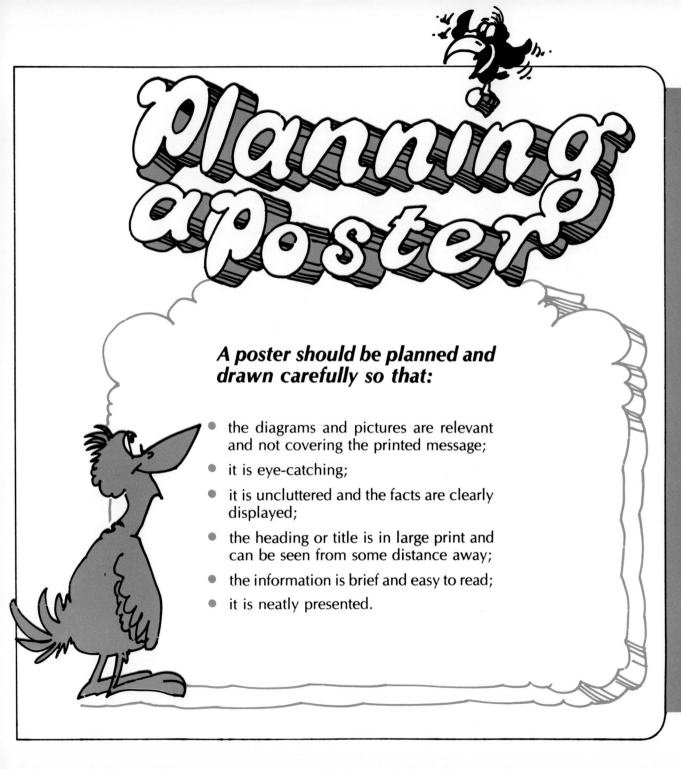

A poster should be planned and drawn carefully so that:

- the diagrams and pictures are relevant and not covering the printed message;

- it is eye-catching;

- it is uncluttered and the facts are clearly displayed;

- the heading or title is in large print and can be seen from some distance away;

- the information is brief and easy to read;

- it is neatly presented.

Some Tips for Projects

□ Work out how long you have in which to do your work and aim to make the most of it.

□ If possible, plan an outline of your whole project before you begin. Do a rough outline on paper.

□ Borrow as many books as you can on the subject.

□ Observe the way others present their work. Keep an eye out for interesting lettering and design ideas when you are looking through newspapers, magazines and books.

□ Plan your color scheme.

□ Keep in mind the motto 'What I do, I do well'. Quality should come before quantity.

□ Select a lettering style for your headings and subheadings. Your project will look best if you keep the same style throughout.

□ Draw your letters lightly, so that if changes are required you do not need to erase hard on the paper.

□ A thoughtful title page is a good start. Leave space for a contents page when you begin, and fill it in when your project is finished.

□ Avoid leaving spaces. Plan your page presentation before you begin.

□ Make an effort to complete each page before beginning a new one.

□ Label all pictures and diagrams with the necessary captions.

□ Use borders and rules to give your work a finished look.

□ Keep a loose leaf of paper under your hand, if necessary, to keep your work clean.

□ Your last page should be as carefully presented as your first.

□ Do not leave the hardest things until last.

□ Avoid unfinished work — the sign of the 'last-minute rush'.

Here are some hints for writing your text material and presenting it on the page.

☐ Read carefully through your sources of information to find the facts that are meaningful to you, that are relevant to the topic and that you would like to remember.

☐ Try not to copy word-for-word from the books you use. It is best to express information from a book in your own words.

☐ Facts are often easier to read and learn if you present each one on a new line.

☐ Include paragraphs and spacing to improve the appearance of your page. A solid page of text can be difficult to read.

☐ Where possible, include subheadings throughout the text to draw attention to the different areas you have written about in each topic.

THE EAGLE

Appearance

Distribution

Habitat

Nest and Young

Food

Interesting Facts

☐ When presenting a research assignment that has many questions, you can use another approach. Write the question in print or color and follow with the answer written in cursive.

☐ When listing lots of facts, you can arrange them in point form. In this way you can number them or use markers.

Designing a Page

When you design a page, you are planning the best way to position your text and pictures. (Of course you will also need to consider headings and captions — these are treated on pages 9 and 11.)

Shown below are a variety of page designs. These may give you ideas for a design to suit your topic.

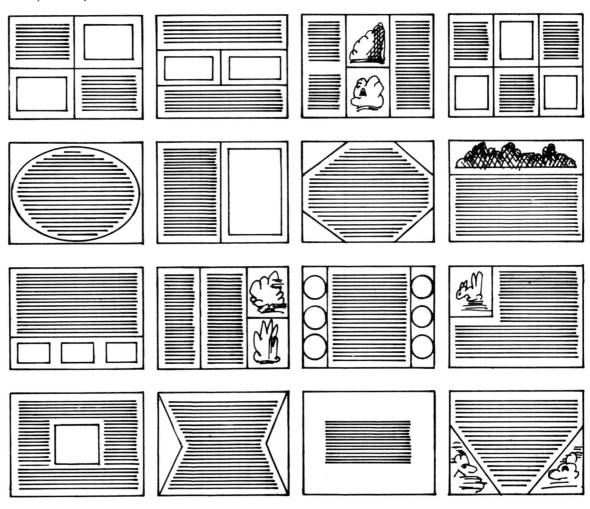

Here are some points to keep in mind when you are lettering headings.

▶ Select a style that suits your topic and is not too hard for you.

▶ Choose a size that will fit into the space you have to use.

▶ Consider the time you can afford to spend on your headings.

▶ Draw guidelines in pencil for the top and bottom of the letters. Later you can erase these. Remember, the wider the lines are apart, the larger your printing will be.

▶ Remember that headings should be clear and easy to read.

▶ An effective heading should also catch the reader's eye.

▶ First, lightly sketch an outline of the heading in pencil.

▶ Never break a word in a heading, as this shows bad planning.

This

not this

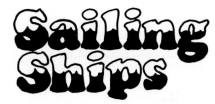

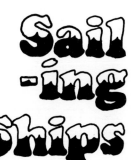

▶ Repeat the same basic style throughout your work, rather than use different styles.

▶ Plan your color scheme. More than two colors can be time-consuming and are often less effective.

▶ Main headings should be larger than subheadings.

▶ Remember that the more difficult styles do not always necessarily look the best.

▶ Try to develop an ability to use several styles that appeal to you.

Headings

Usually headings and titles are drawn across the top of a page. However you can introduce eye-catching effects by using different positions for headings, as shown below. Many interesting ideas for presenting headings can be found on the pages in this book.
Look for one to suit your topic.

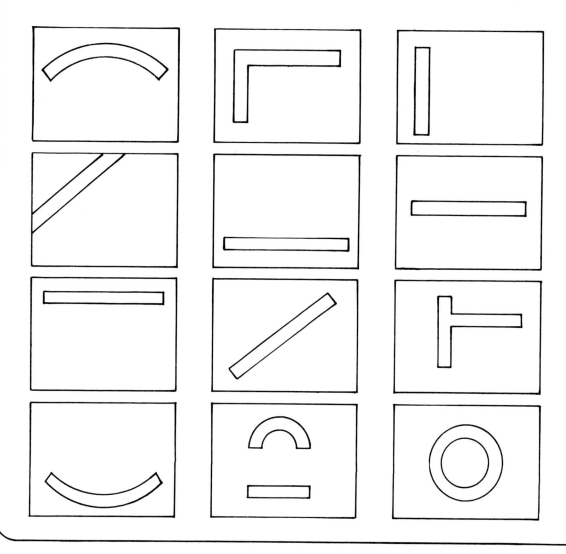

Make the most of the pictures you want to use by cutting them out neatly. You can cut them . . .

around the shape

or

with straight lines and square corners

or

by using pinking shears.

All pictures should have a printed caption . . .

above

or

or

beside the picture.

below

Rule some pencil lines to use when writing the captions and then erase them.

A picture can look more attractive with a frame drawn around it. (See 'Borders', page 18.)

The positioning of pictures and captions is important when you are designing a page. Here are some effective arrangements.

Two pictures with captions

**Three pictures
with captions**

**Four pictures
with captions**

You can make more than four pictures look
effective by pasting them with the pictures
overlapping.

- Sketch the basic outline of your drawing in pencil. When completed, hold it out in front of you and ask yourself *'Does it look right?'*

- If you are copying from a difficult picture, sketch the main shape first and draw in the details last.

- Remember that there are different kinds of drawings, such as:

 > a sketch,
 > a diagram with captions,
 > a map with a key,
 > and a scene.

- When drawing a scene, keep in mind that there are three areas to consider: the foreground, the middle distance and the background.

- The main subject of your drawing should be clearly seen. The most important object is usually the largest. Remember that objects in the foreground are generally drawn larger than those in the background.

 BACKGROUND

MIDDLE DISTANCE

FOREGROUND

- Whenever possible draw your sketch while looking at the real thing.

- The drawing should match the description or facts in your text. Ideally it should be placed on the same or the opposite page.

- Drawings can be done by a number of methods: freehand; tracing (directly onto the page or by using tracing paper); reducing or enlarging (using modern aids); and outlining (using a grid of horizontal and vertical lines to give accurate proportions).

- Use true-to-life colors for animals, plants and natural objects.

- To clearly define the drawing, you may wish to draw an outline in a darker color. (A fine, felt-tipped pen is good for this.)

- You can give your drawing a pleasing effect by lightly shading the area round it in color. Use shavings from a colored pencil and smear them with your finger or a piece of paper.

Ways to Vary a Printing Style

Take, for example, a basic, rounded block style: e.g.

The letter shapes can be altered in many ways by changing the *height, width, slope* and *outline*. Different styles can be created by using variations in color and pattern, and by special effects such as 3-D, separating and overlapping.

HEIGHT

WIDTH

SLOPE

LINE VARIATIONS

PATTERN (and color)

3-D EFFECT

SEPARATING

OVERLAPPING

When you are drawing and using letters, there are two things about spacing that are useful to know.

1. Some letters take up more space than others. For instance, M and W are wide, while I and L are narrow. Allow for this when you are designing headings. Avoid squeezing a wide letter into a narrow shape — it will look out of place with the others.

2. You will need to use different spaces between certain letters when forming words. The rounded and oddly shaped letters will need careful positioning. If each letter were to be placed an equal distance apart, the result would look strange.

SPACING

Some letters need to be placed close together to make the word look right.

SPACING

You do not need to measure spacing: your eye is your best guide. Spend some time looking closely at the spacing used in titles on magazines, books and record covers. With practice you will soon develop confidence in judging spacing and be able to see if there is too much space (or white area) between letters.

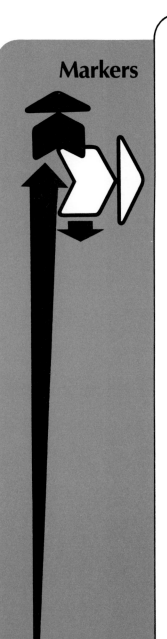

Markers

There are endless variations of markers and numbering styles you can use to indicate new facts or items within the text. The following should give you an idea of the range you can use and help you invent some of your own. Markers are also often called pointers.

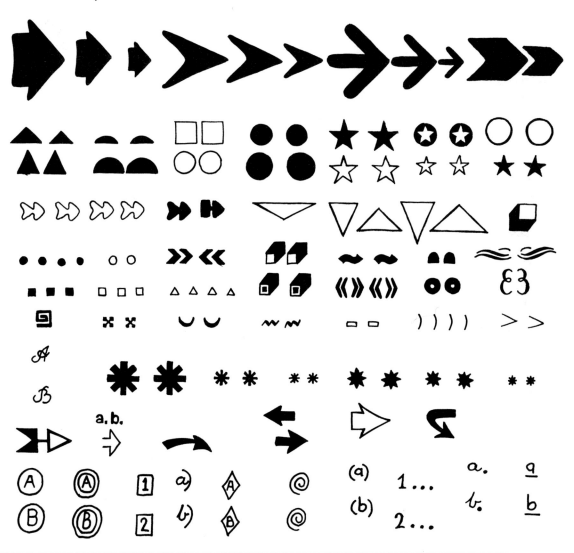

Rules can be used to separate sections of your page and to improve its appearance.

★ Rule across the top and bottom of your page.

★ Underline headings and subheadings.

★ You may decide to draw a line under the important words in your sentences. This should be helpful for studying and recalling the main points at a glance.

★ Draw a rule (simple or fancy) beneath each section of your work. Some examples of fancy rules are shown below.

You may choose from these, or use them for ideas from which you design your own.

Borders

You can use borders to decorate the edges of a page, whether the page contains text or pictures. They can also be used around individual pictures, special facts, or even a collection of points. Borders are often called frames when they are placed around an illustration.

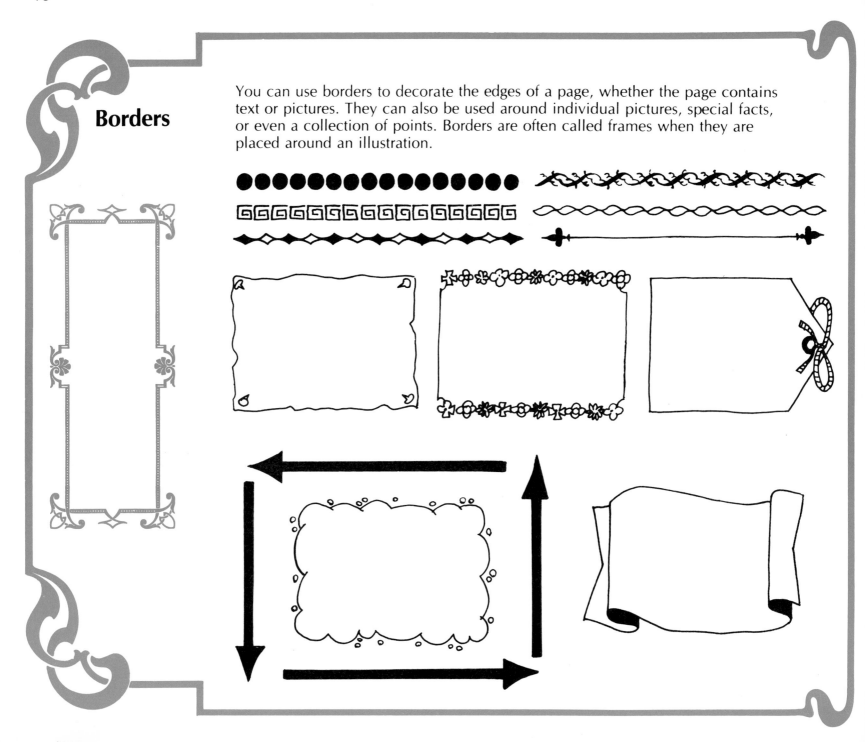

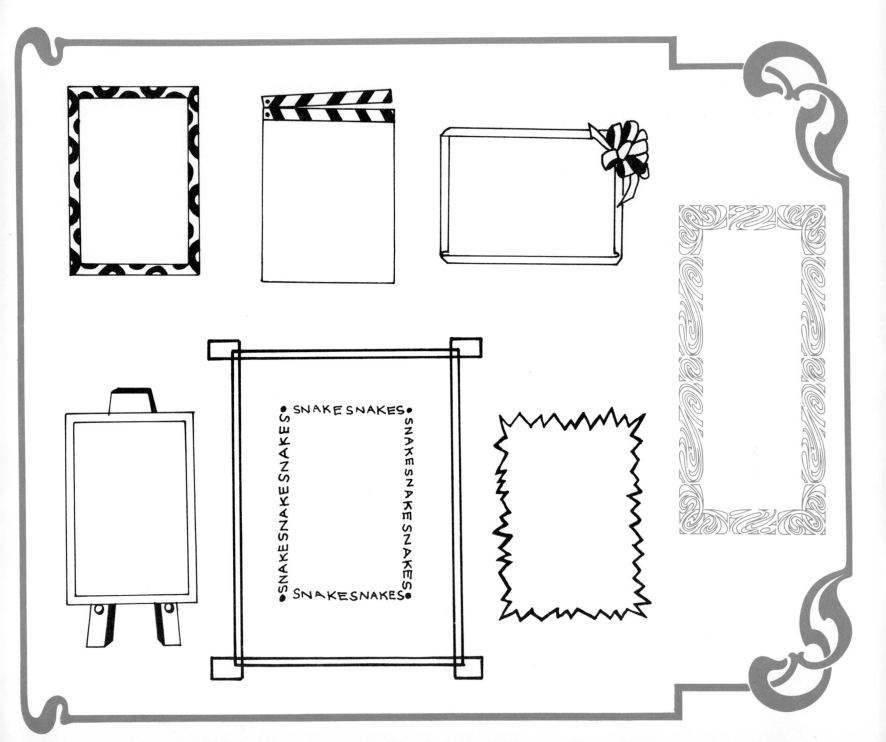

Numerals

1234567890

1 2 3 4 5 6 7 8 9 0

1234567890

1234567890

1234567890

1 2 3 4 5 6 7 8 9 0

1234567890

1234567890

1234567890

1234567890

1
23
456
7890

1234567890

1234567890

1234567890

1234567890

1234567890

1234567890

1234567890

1234567890

1234567890

1234567890

1
23
456
7890

Sans Serif Lettering Styles

HELVETICA REGULAR

ABCDEFGHI
JKLMNOPQ
RSTU VW
XYZ

abcdefghijkl
mnopq rst
uv wxyz

ABCDEFGHIJKLMNOPQR
STUVWXYZ
abcdefghijklmnopqrstuvw
xyz

**ABCDEFGHIJ
KLMNOPQRST
UVWXYZ
abcdefghijkl
mnopqrstuvw
xyz**

FUTURA
LIGHT

GILL KAYO

FRANKFURTER
HIGHLIGHT

ABCDEFGHI
JKLMNOPQ
RSTUVWXYZ

FUTURA
BLACK

ABCDEFG
HIJKLMN
OPQRST
UVWXYZ

ABCDEFGHIJKLMNOPQRSTUVWXYZ

abcdefghijklmnopqrstuvwxyz

**ABCDEFGHIJKLMN
OPQRSTUVWXYZ**

**abcdefghijklmnopq
rstuvwxyz**

VANCOUVER

HELVETICA
CONDENSED

HELVETICA
BOLD

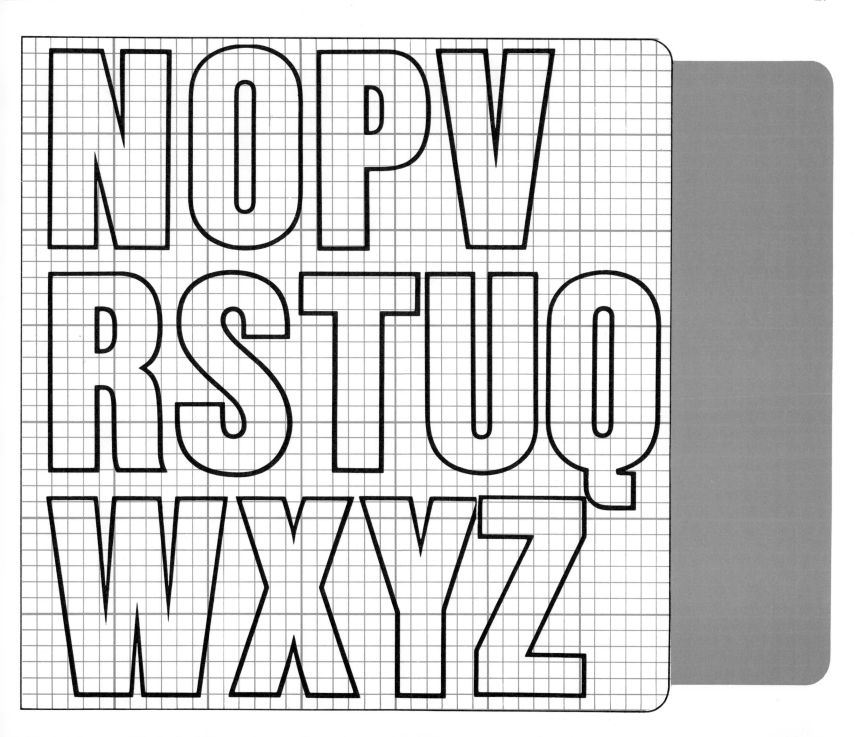

UPTIGHT
NEON

ABCDEFGHIJKLMN
OPQRSTUVWXYZ

BROADWAY

ABCDEFGHIJKLMNO
PQRSTUVWXYZ
abcdefghijklmnopq
rstuvwxyz

BLIPPO
BLACK

ABCDEFGHIJKLMNOPQRSTUV
WXYZ
abcdefghijklmnopqrstuvwxyz

DATA 70

ABCDEFGHIJKLMNOP
QRSTUVWXYZ

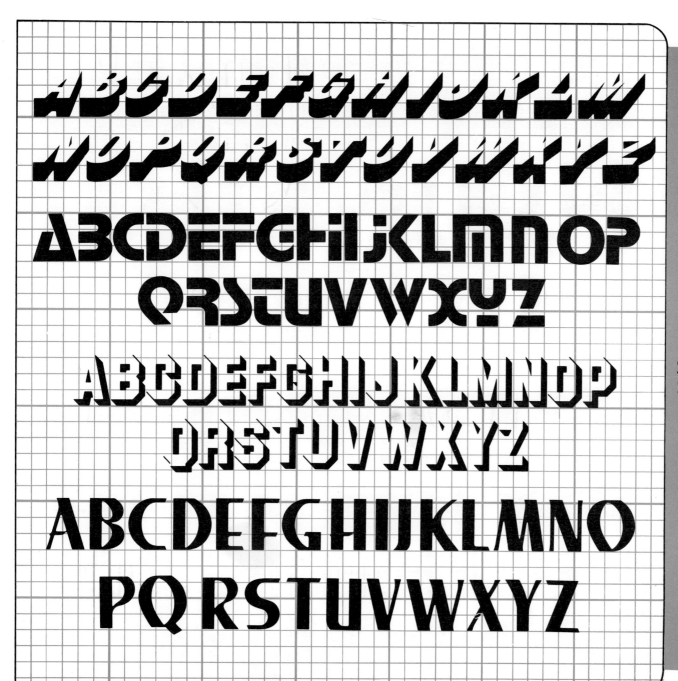

BUSTER

STOP

SUPERSTAR SHADOW

LEE BOLD

MICROGRAMMA
BOLD EXTENDED

ABCDE
FGHIJK
LMNOP
QRSTU
VWX
YZ

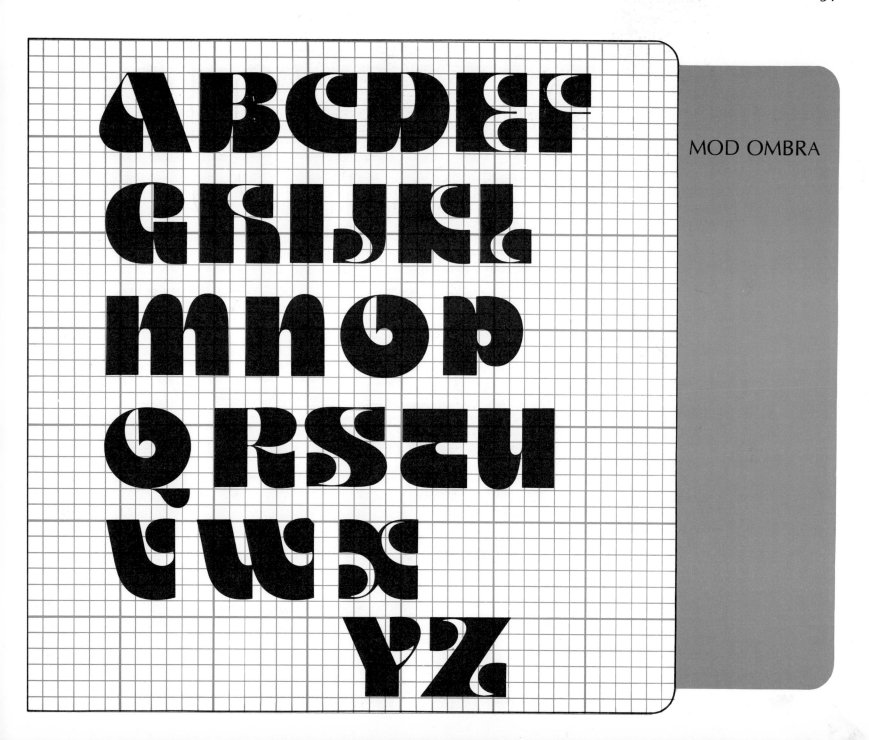

MOD OMBRA

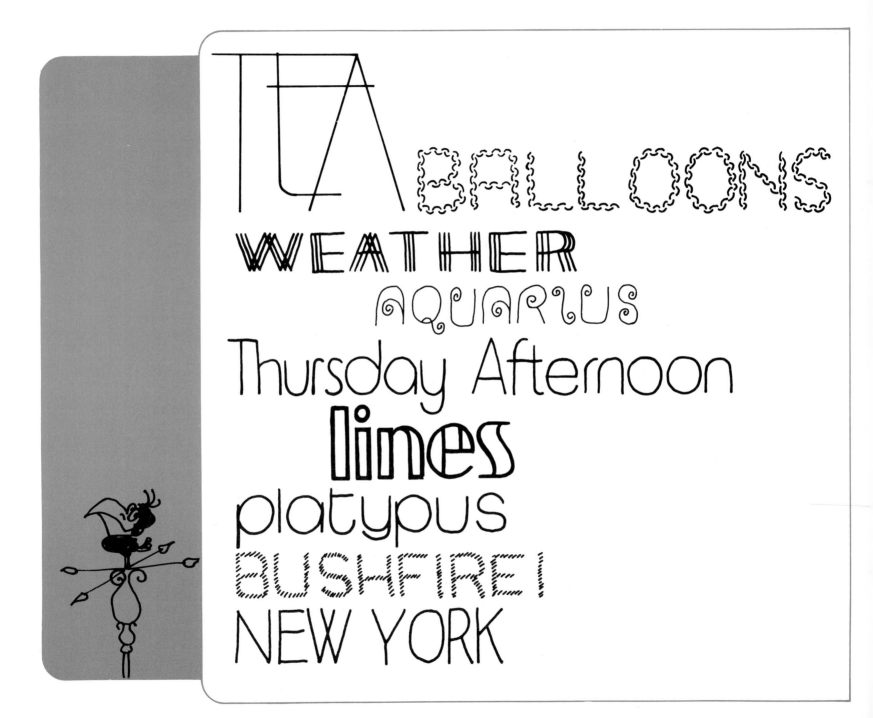

TEA
BALLOONS
WEATHER
AQUARIUS
Thursday Afternoon
lines
platypus
BUSHFIRE!
NEW YORK

LIGHT

FOOD
CHAIN

INVENTIONS

Design

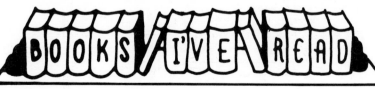

Signs

ENTERTAINMENT

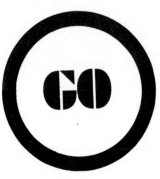

BOOKS I'VE READ

THE HOLY BIBLE

HISTORY

GO

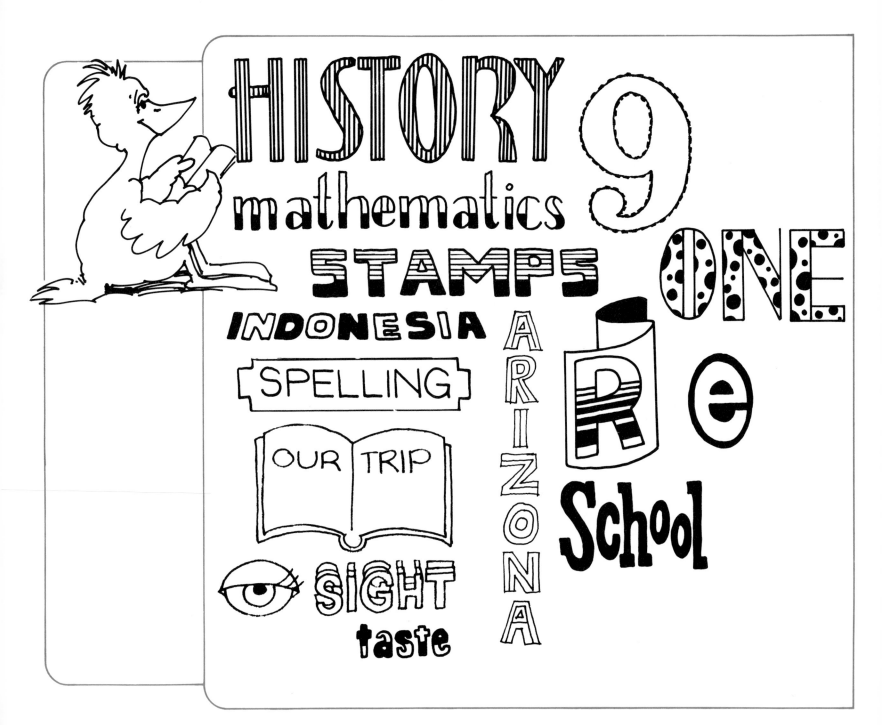

A DAY IN MY LIFE

FISH

MAN'S BEST FRIEND

OUR FEATHERED FRIENDS

THINGS I LIKE

POP STARS

SEWING

MY DOG DANNY

ON THE FARM FOOD

FOSSILS ★FACTS★

YES
PRESIDENT
MONEY
EMPLOYMENT
WASTE NOT
WANT NOT
INDIA

1ST PRIZE

YEAR 3

EDUCATION

SIZE

MOUNTAINS

NEW ZEALAND

CANADA OUR EARTH

USA HAWAII

LONDON

HONG KONG

MEXICO

COMMUNICATIONS

HOME

FOOTBALL **START** coloring-in ~~ANIMALS~~

EIGHT PLACES

ATHLETICS PETS

SEPTEMBER CAPRICORN

A TRIP TO THE ZOO

ELEPHANTS

MACHINES

SPACE AGE

EARTHQUAKE!

NASA

DANGER

COAL

FIRE

LAND

FARM LOST

CONSERVATION

NOISES IN THE NIGHT

QUESTION ANSWER

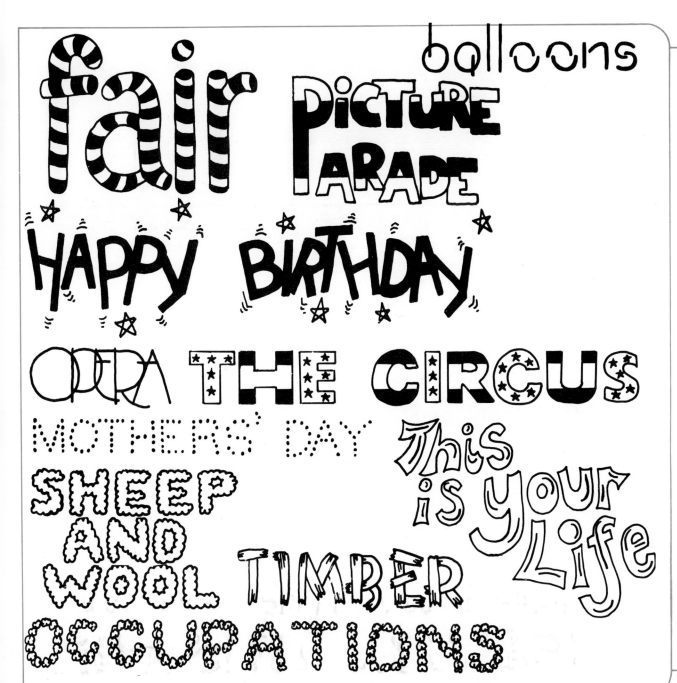

fair

balloons

PICTURE PARADE

HAPPY BIRTHDAY

OPERA THE CIRCUS

MOTHERS' DAY

This is your Life

SHEEP AND WOOL TIMBER

OCCUPATIONS

February
march
MAY AUGUST
WINTER
RAIN
the sun
HOLIDAYS
SATURDAY
LEAVES

education

The Computer **WRITING**

WORKBOOK

INSECTS FLIES

BUTTERFLIES

AMERICAN ANIMALS

guide

SCHOOL REPORT

CRASH!

down

ROOM 2

THERE'S NO PLACE LIKE HOME

A DAY TO REMEMBER

DAIRY PRODUCTS

SHOPPING

SAFETY FIRST

A PARTY A CITY

IN OUT Industry

GOVERNMENT

PRODUCT

THE SECRET

HELP!

MAGIC

DROUGHT

NEIGHBORS

REPORT

review

looking at the details

Taurus

art COLOR

footsteps...

Lightning!

TIMES
NEW ROMAN

ABCDEFG
HIJKLMN
OPQRSTUV
WX YZ
abcdefghijkl
mnopq rst
uv wxyz

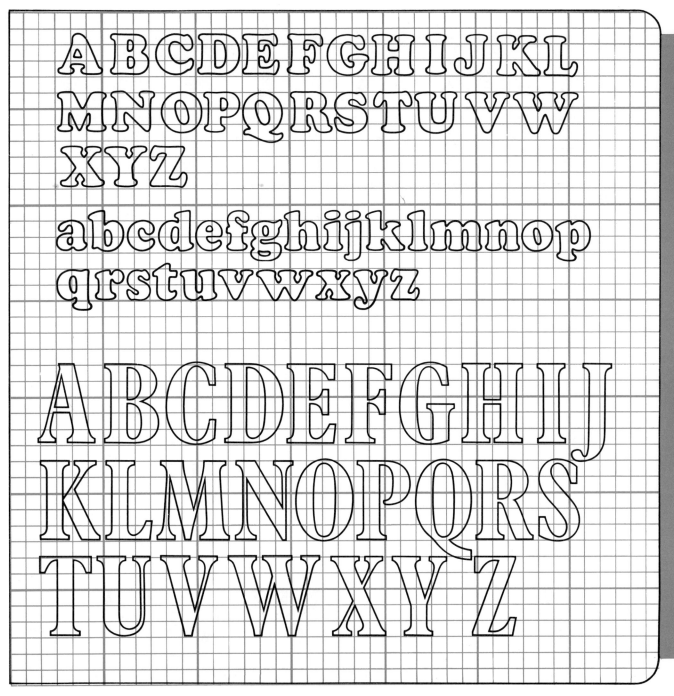

ABCDEFGHIJKL
MNOPQRSTUVW
XYZ
abcdefghijklmnop
qrstuvwxyz

ABCDEFGHIJ
KLMNOPQRS
TUVWXYZ

COOPER
BLACK
OUTLINE

PLANTIN
BOLD
OUTLINE

48

ALGERIAN

AABCDEFGHHIJK
KLMMMNNOPQRR
SSTUVWXYZ

BELWE
BOLD

ABCDEFGHIJKLMN
OPQRSTUVWXYZ
abcdefghijklmnopqr
stuvwxyz

PEORIA

ABCDEFGHIJKLM
NOPQRSTUVWXYZ
abcdefghijklmn
opqrstuvwxyz

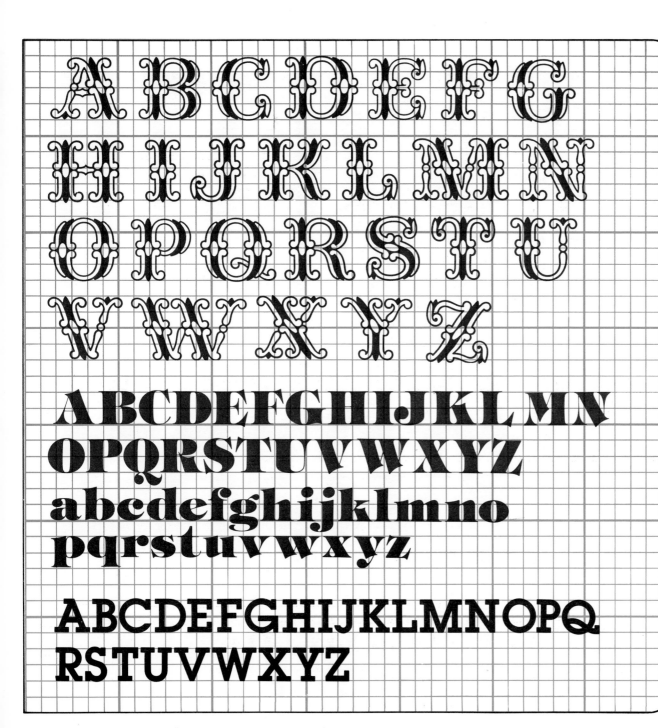

TIFFANY
HEAVY

LUBALIN
DEMI BOLD

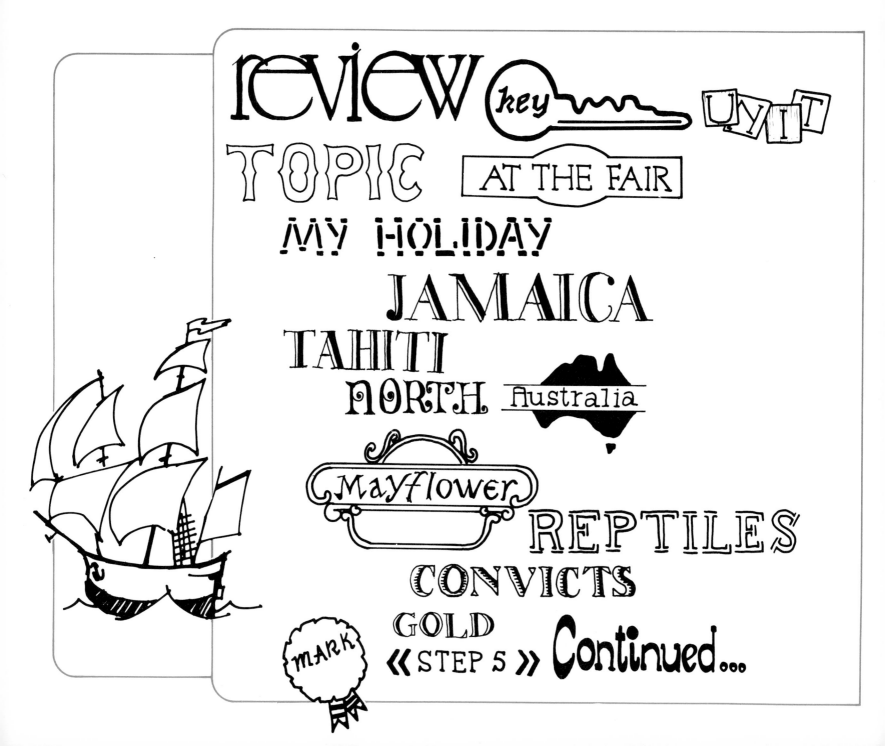

review (key) UNIT

TOPIC AT THE FAIR

MY HOLIDAY

JAMAICA

TAHITI

NORTH Australia

Mayflower

REPTILES

CONVICTS

GOLD

MARK

« STEP 5 » Continued...

tomorrow
January APRIL
EASTER
READING OCTOBER
NOVEMBER
GOOD KING WENCESLAS
THE ZODIAC THE SUN

LEO

GEMINI
LIBRA CANCER

VIRGO

MAN IN SPACE

IRON AND STEEL

ROADS

CARS

MACHINES OIL

AT THE AIRPORT

TRANSPORT

HELPING OTHERS

THE UNIVERSE

AMERICAN
ANIMALS

WOLF
COYOTE

SHARKS

Snake

ASIA

FAMOUS PEOPLE

KING
HENRY VIII

ENGLAND

China

ANTS

SUN, SURF AND SAND

Cats

MARCO POLO

LEONARDO DA VINCI

BOYS and GIRLS

W

WILD WEST

fruit and vegetables

HERS HIS

MAN

sport

soccer

ENTERTAINMENT

BIRTHDAYS

PEACE ONE SILVER

LOVING MUSIC LOVE

BEAUTIFUL THINGS

FACES

THE LAW AND YOU

WANTED · DEAD OR ALIVE

STENCIL
BOLD

ABCDE
FGHIJK
LMNOP
QRSTUV
WXYZ

ABCDE
FGHIJK
LMNOP
QRSTU
VWXYZ

PROFIL

Script and Decorative Styles

ABCDEFG
HIJKLM
NOPQRS
TUVWXYZ
abcdefghijklmno
pqrstuvwxyz

OLD ENGLISH

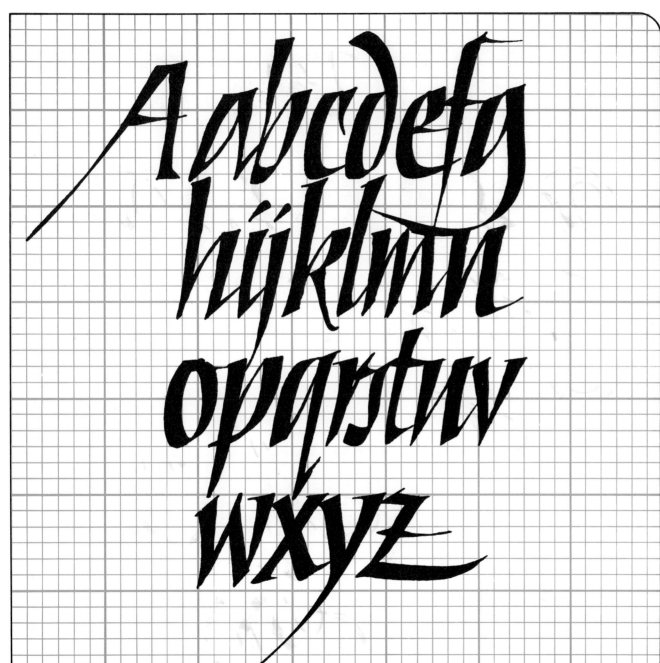

CALLIGRAPHIC

SCRIPT
(LETTERFORM
No. 2)

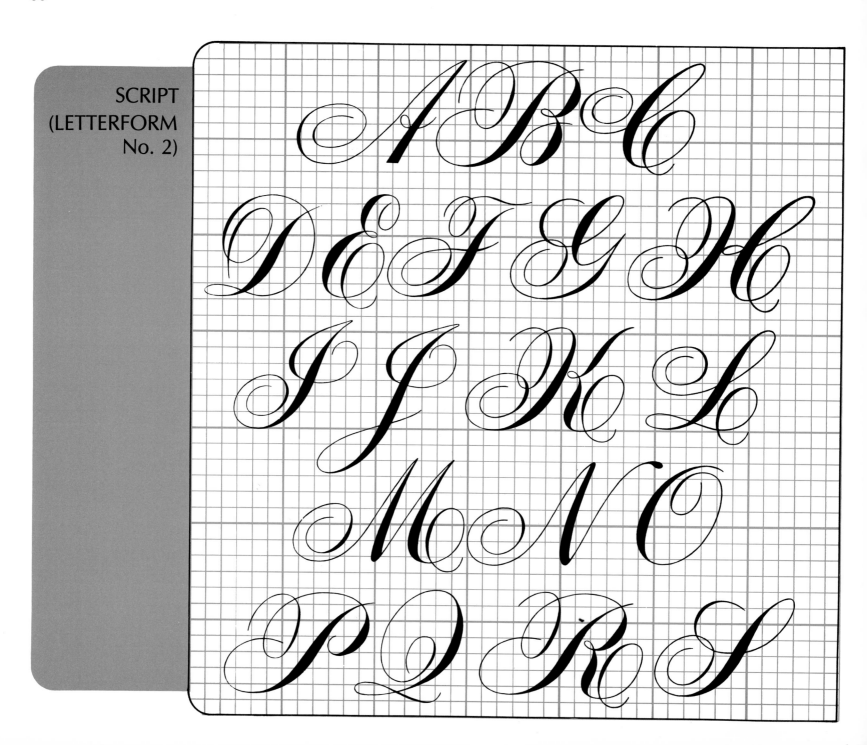

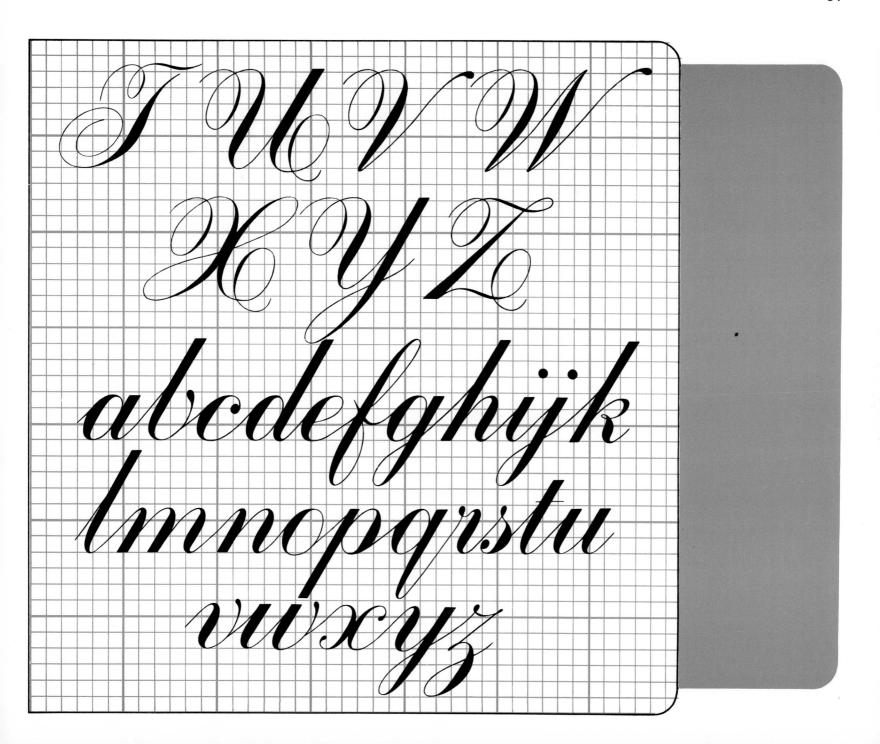

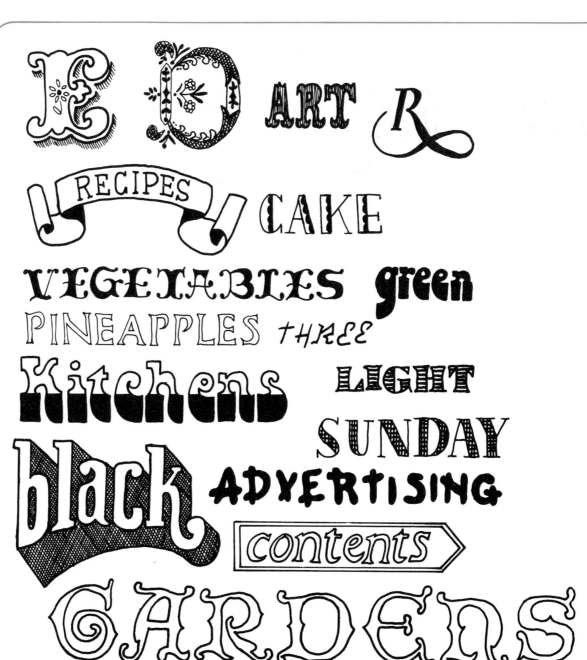

Christmas Greetings

SUGAR Chanuka

FINISH Valentine's Day

The Seashore Greetings

THE HAUNTED HOUSE

Season's Greetings

FLORA FAUNA

DANCING UNIT EIGHT

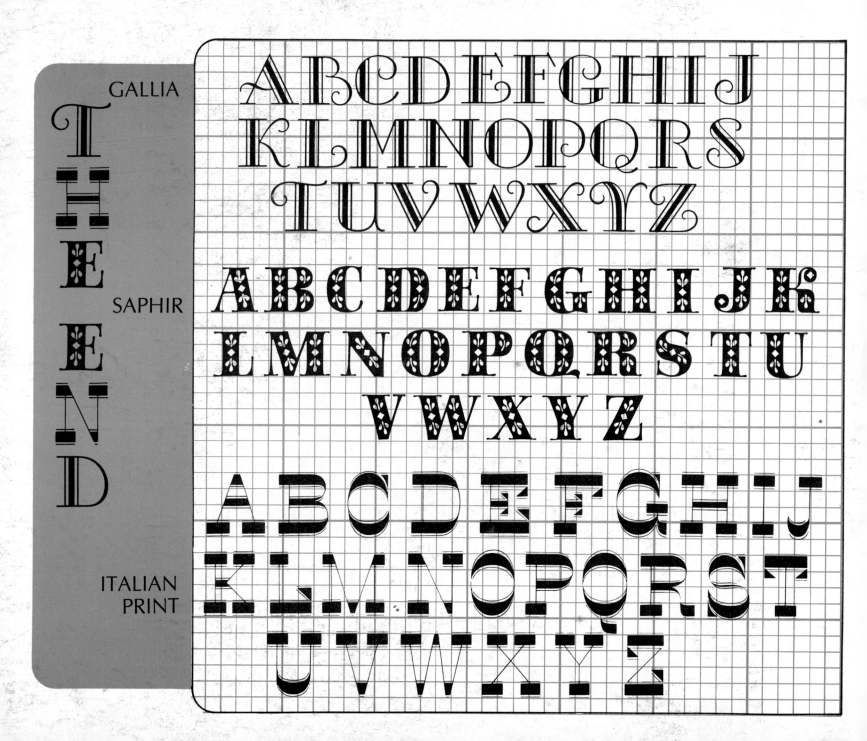

GALLIA

SAPHIR

ITALIAN
PRINT

THE END